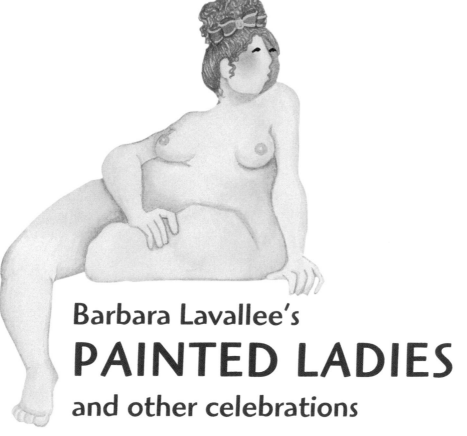

Barbara Lavallee's
PAINTED LADIES
and other celebrations

About the cover

Between painting trips to Africa and Israel, with the added pressure of an upcoming show and charity fund-raiser in Fairbanks, and the new catalog business we've started in Anchorage, not to mention the phone ringing off the hook, the *last* thing I wanted to do in the fall of 1994 was another painting. Yet, B.G. Olson and Kent Sturgis of Epicenter Press insisted a fresh, new image was needed — something to carry the title of this book.

When I finally resigned myself to the inevitability of cramming a new cover into my schedule, I found it to be a very special piece, full of meaningful and memorable favorite ladies I had done in the past as well as a piece I had wanted to do.

The composition began with the nude sitting on the ISBN number and barcode. She set the right tone of fun and flamboyance. I had many images from my trip to Russia, but the one I chose to paint was the babushka, the Russian grandmother. I saw this woman, with her wonderful broom, sweeping outside the train station in Khabarovsk.

The lady from Japan, the potato stomper from Bolivia, and the flower lady from Mexico are favorites from books I've illustrated. The Hopi Basket Dancer represents the American Southwest. I chose her because of her magnificent hairdo, which provides a nice balance to the Japanese lady, and a good contrast to all the braids.

And B.G. wanted an African lady. I'd been itching for an excuse to paint a Masai lady since my return from Kenya in November. Here was my chance! I saved her for last. I wanted her to be the figure who brought this painting to life. She is a departure for me — a thin woman! Perhaps there is more to paint than undulating flesh.

Barbara Lavallee

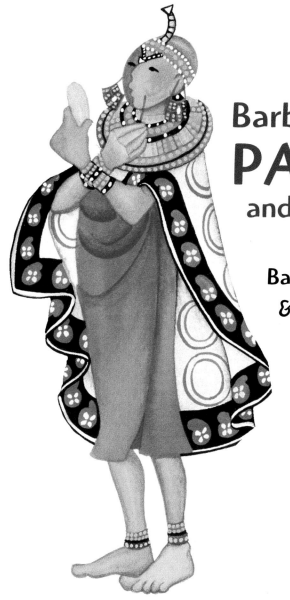

Barbara Lavallee's
PAINTED LADIES
and other celebrations

Barbara Lavallee
& B.G. Olson

Epicenter Press

Fairbanks / Seattle

Project editor: B.G. Olson

Copy editor: Christine Ummel

Prepress and printing: Color Magic, Inc.

Production and binding: Lincoln & Allen

Production manager: Dick Owsiany

Cover and book design: Newman Design/Illustration

Several images in this book first appeared in the Imagine Living Here series from Walker & Co., New York, and are reprinted with permission. Other images reprinted with permission are from the books *Mama, Do You Love Me?,* by Chronicle Books, and *The Snow Child,* by Scholastic.

Library of Congress Cataloging-in-Publication Data

Olson, B.G.
Barbara Lavallee's painted ladies : and other celebrations /
artwork by Barbara Lavallee ; text by B.G. Olson

 p. cm.

ISBN 0-945397-36-4 : $34.95. — ISBN 0-945397-37-2 (pbk.) : $22.95
 1. Lavallee, Barbara—Catalogs. 2. Women in art—Catalogs.
 3. Costume in art—Catalogs. I. Lavallee, Barbara. II. Title.

ND1839.L355A4 1995

759.13—dc20 94-23777
 CIP

To order single copies of BARBARA LAVALLEE'S PAINTED LADIES, mail $34.95 each for a hardcover edition (Washington residents add $2.87) or $22.95 each for a softbound edition (Washington residents add $1.88) plus $5 each for shipping to: Epicenter Press, Box 82368, Kenmore Station, Seattle, WA 98028.

Booksellers: Retail discounts are available from our trade distributor, Graphic Arts Center Publishing Co., Box 10306, Portland, OR 97210. Phone 800-452-3032.

PRINTED IN THE UNITED STATES OF AMERICA

First printing, March, 1995

10 9 8 7 6 5 4 3 2 1

Dedicated to my father and mother,
Clarence and Dorothy Koehler,
Who taught me to believe I could,
And to all the sumo wrestlers I've known

ACKNOWLEDGEMENTS

There are many people who contributed to the making of this book and who deserve my heartfelt thanks — none more than B.G. Olson, who I call "Beege." With patience and tenacity he worked around my schedule, delved into my past, sometimes wheedled and cajoled, reminded me of deadlines, and ultimately put into words the Barbara Lavallee you meet in these pages. Beege has become a special friend, one worthy of the greatest honor I bestow — a spot in a painting someday.

Susan Ellis and Holly Hobson of Artique, Ltd. for orchestrating and organizing the enormous task of collecting and supervising the photographing of the images shown in the book. Tennys Owens, owner and president of Artique, long-time publisher and friend, who believed in me from the start and has taught me volumes about the business of art.

And of course, my family, for providing me with endless "grist for my mill."

I am grateful to all of you.

Barbara Lavallee

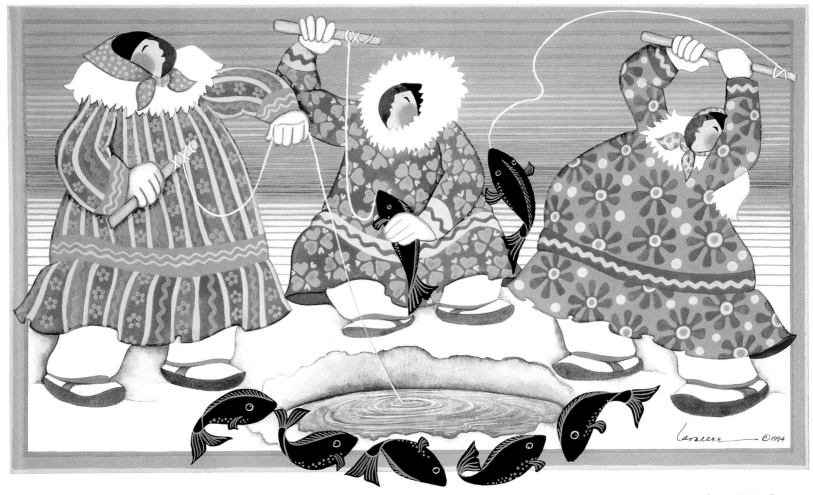

ICE FISHING, *1994*

Barbara Lavallee's
PAINTED LADIES
and other celebrations

Barbara Lavallee is a woman who refuses to be pigeon-holed. She has moved freely in several worlds — that of a strong, independent woman firmly rooted in day-to-day reality where she has been an art student, restaurant operator, social worker, teacher, and devoted mother who raised two sons single-handedly ... that of an award-winning children's book illustrator who has traveled to the ends of the earth on assignment ... and that of an accomplished Alaskan artist who is just as comfortable in an Eskimo village as she is at a gallery opening in Anchorage.

That her experiences have given her an optimistic, joyful outlook on life, focusing on the positive aspects of people — especially women — is seen vividly in these pages.

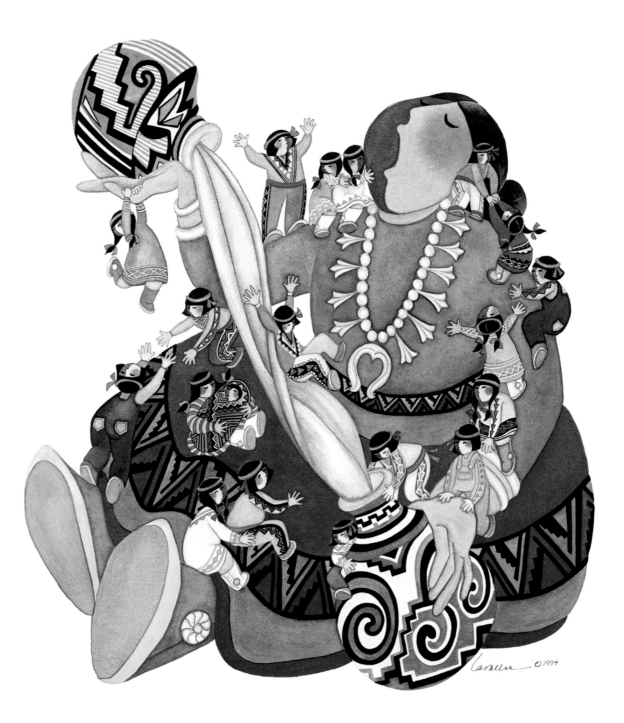

"I'm a woman and I do women ... I do some men and kids in my paintings, but seldom do a painting of just men. Women are so much more colorful."

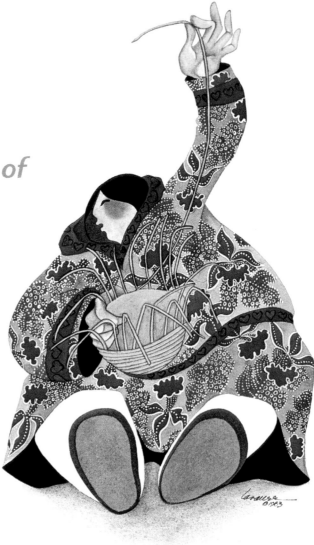

◄ **SOUTHWEST STORIES**
watercolor, courtesy of Gordon and Alice Godfred, 1994

In the late 1960s, I spent several years living on the Navajo Reservation in Arizona and taught art classes there. Twenty years after leaving the area, I finally completed my storyteller. Apparently some subjects require more stewing than others.

BASKET WEAVER
watercolor, 1983

Except for the Eskimo kuspuk she wears, this basket weaver, performing her universal task, could come from almost anywhere.

LAST ONE IN
watercolor, 1981

Some art school rules become so well learned that they're hard to break, such as "three figures in a composition make it more interesting than two or four." If I had broken that rule with this painting, there would have been four ladies instead of three, because it has always made me think of my sisters and me — though we romped in Lake Michigan and I painted this in Hawaii.

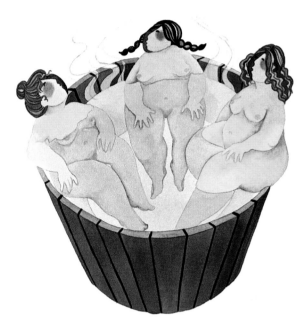

TOM'S TUB
watercolor, 1980

*A Valentine's Day present for my husband Tom
one year, this was my first hot tub painting.
Several years after we were divorced, I received a
call from someone in Kodiak, Alaska, who was
trying to verify the painting's authenticity. He had
purchased it in the Honolulu airport from Tom,
who was getting ready to return to the mainland
and was lightening his load.*

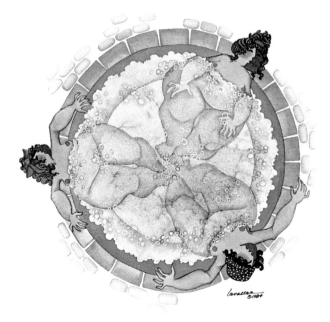

THREE'S A CROWD
watercolor, 1984

*By the time I did this painting, four years after
"Tom's Tub," I had discovered the jacuzzi and
was adding bubbles to my hot tubs.*

ESKIMO MOTHERS

etching, 1980

A print from this edition was purchased by the Alaska State Council of the Arts, to be part of the permanent collection aboard the Alaska State Ferry Matanuska. *I was still experimenting with both style and medium, and etching lends itself to creating a wide variety of textures.*

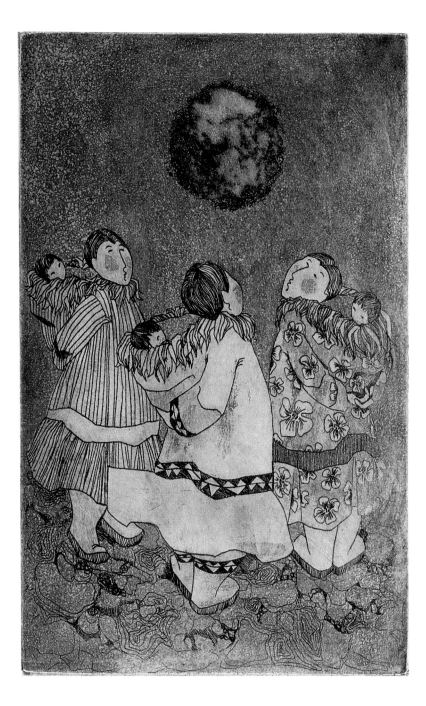

ARCTIC LAUNDROMAT
watercolor, 1994

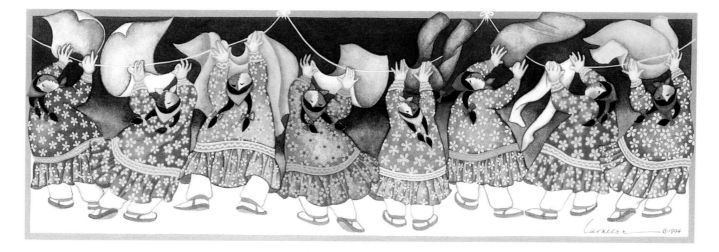

"*Women are the glue of society. I grew up surrounded by women who can take care of themselves. They keep things together, make celebrations happen, care for the emotional and physical needs of the family. They perform the routine chores that keep a home and family running smoothly.*"

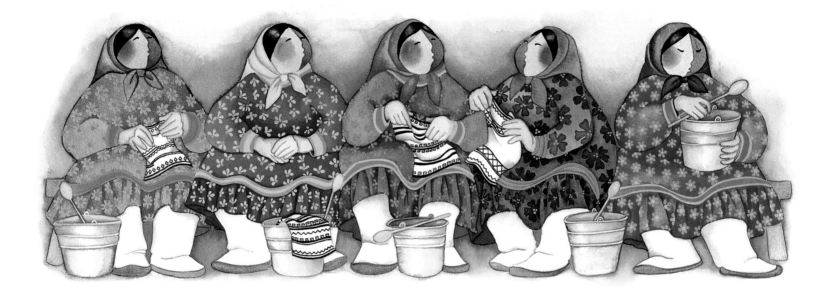

POTLATCH

watercolor, courtesy of the artist, 1994

Potlatch is a rather generic term applied to a variety of sharing ceremonies between villagers and between villages in Alaska. This painting shows a group of Yupik ladies receiving gifts carefully passed to all participants. A new berry bucket holds the "loot," which can be food as well as utilitarian items.

SALMONBERRY PICKERS ▶

watercolor, 1983

Berry pickers are a subject I have painted many times. I spent many happy hours with my children, my friends, and their children picking and eating berries. It is always a happy surprise to come upon a lush berry patch in the wild. Even more amazing is their abundance and importance in the Alaska Bush, where picking berries is more than a summer frolic.

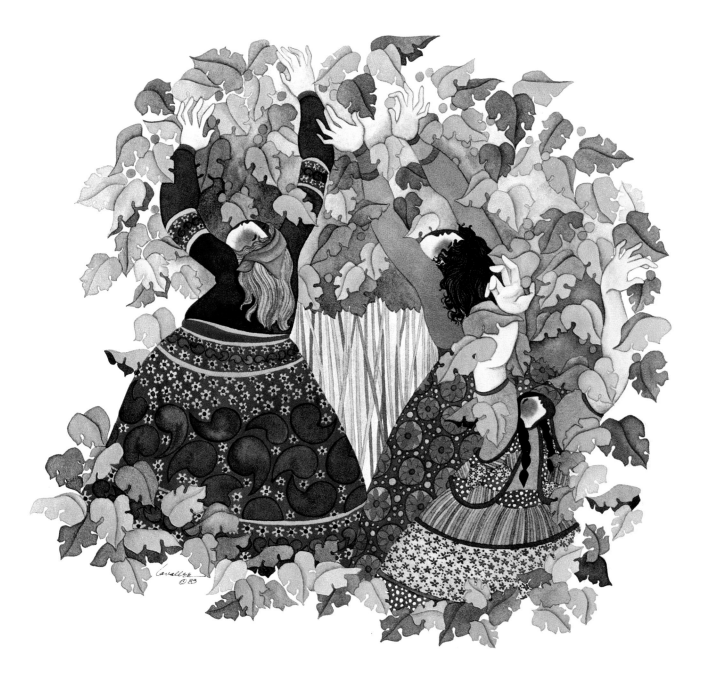

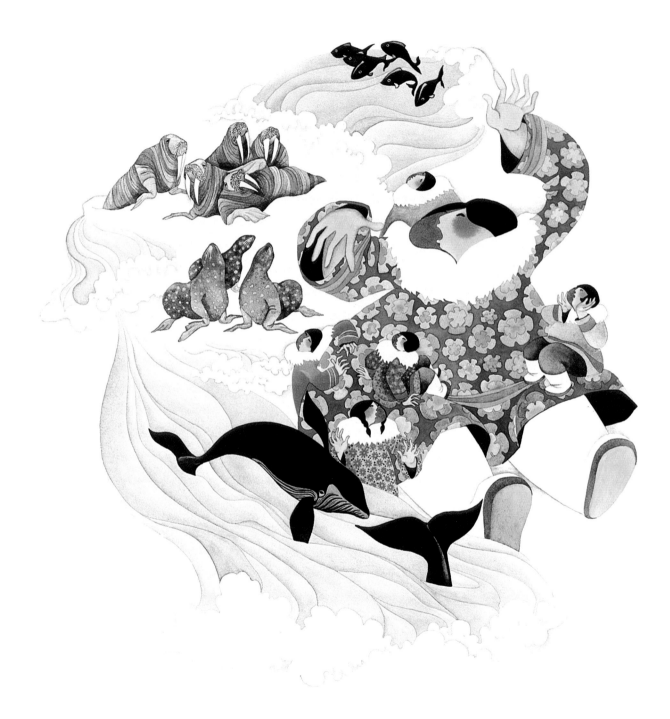

16

"I have met many strong, surviving women who have beaten the odds, so there's no doubt in my mind that women are equal. Sometimes better! I'm very happy being a woman. It's been an exciting time to be a woman."

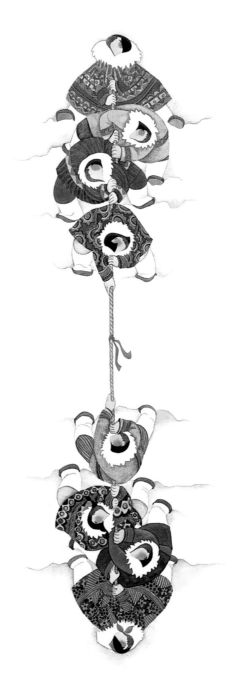

◄ **STORYTELLER**
 watercolor, 1981

 Explaining the world and human beings' relationship with the animals around them, the storyteller has long been entrusted with myths and beliefs, as well as the preservation of culture.

TUG OF WAR
watercolor, 1981

Inspired by photos of an Alaskan village Fourth of July celebration, I distorted the perspective and showed these tug-of-warriors from above.

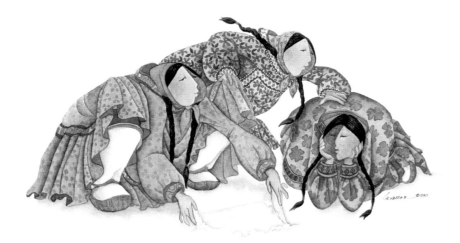

CHILLY TALES

watercolor, 1990

A group of little girls is being entertained by a story told in the snow with the use of a "story knife." Often elaborately decorated and carved of ivory, these knives are used to smooth the surface and to draw the figures and action of a story in snow or dirt.

UPHILL CLIMB

watercolor, 1983

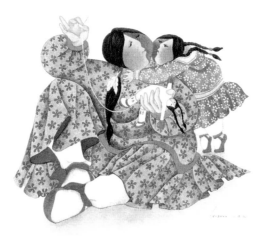

QUALITY TIME
watercolor, 1991

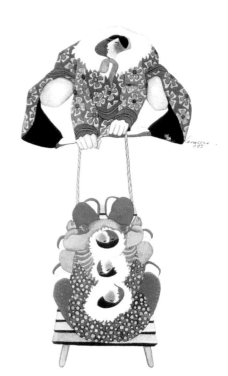

PICKING FORGET-ME-NOTS

watercolor 1983

The Alaska state flower, this hardy little wildflower is often found in precarious and unexpected places.

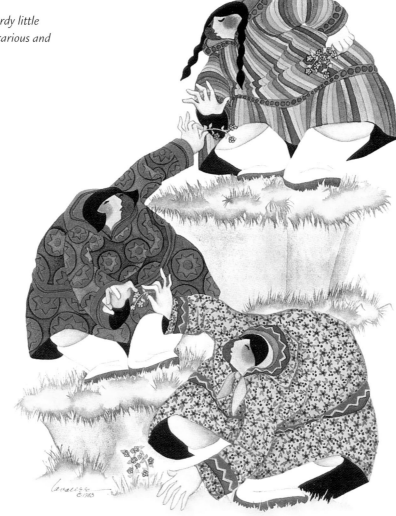

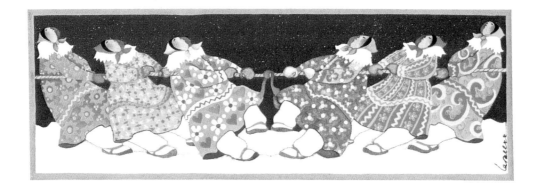

TUG-O-WAR
watercolor, 1993

Like many Eskimo games which require skills used
in a subsistence lifestyle, the tug-of-war (often
played as part of the Fourth of July festivities)
tests the same skills needed to pull a whale on
shore after a successful hunt.

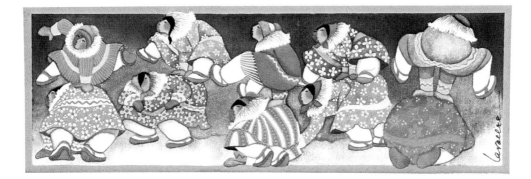

ARCTIC GAMES
watercolor, 1993

There is something so universal about children's
games, and I remember the fun of a good game of
leapfrog in the snow.

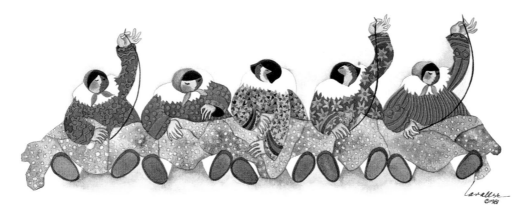

ESKIMO STITCHERY

watercolor, 1981

A quilting bee in the Alaska "Bush." There is a universal quality to working together that is common to all cultures.

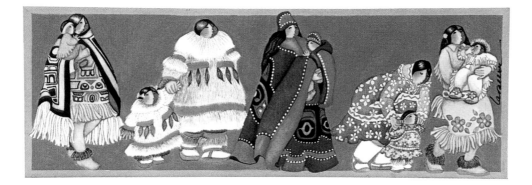

TREASURED TRADITIONS

watercolor, 1993

In the Indian and Eskimo Olympics, held every year in Fairbanks, the procession for the Mothers and Babies Contest begins with a Chilkat blanket, followed by Yupik fur parkas, Tlingit button blankets, Inupiaq kuspuks, and Athabaskan skin and bead work.

*"The women I paint are monumental ...
women of substance ...* well-rounded, with creases and folds and
rolls to create shadows. I do not
consider them fat. But they are
not mere pieces of fluff in
danger of blowing
away in the next
high wind, either."

NUDE IN STOCKINGS ON UNICYCLE

etching, 1981

The absurdity of a nude woman riding a unicycle is so appealing to me that it is a subject I have done several times in a number of media. I feel a certain kinship with her (though I envy her abandon), because I have often compared the public display of something so personal as your art to running through the streets naked. When my sons and I were deciding on an image for our catalog logo, the choice of the nude on the unicycle was unanimous.

◀ PILLOWS GALORE

stone lithograph, 1986

Stone lithography is a deliciously challenging medium in which each color is done separately on a huge slab of limestone, then all the colors are carefully printed onto paper to form a single image. When experimenting with a new medium, like stone lithography, I like to choose subjects that border on the absurd because it keeps me from getting too serious about the work I'm doing. The mottled flesh tones of the nude, the pattern of the pillows, and the textures of the cats gave me a chance to play around with a sampler of techniques.

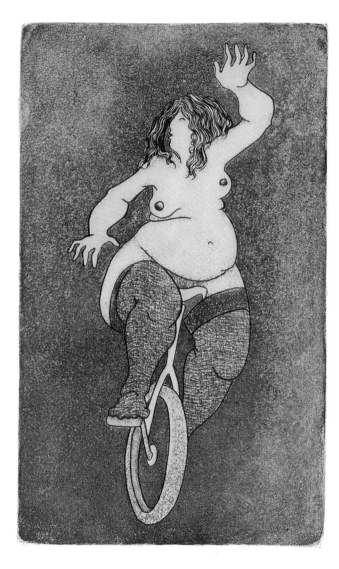

23

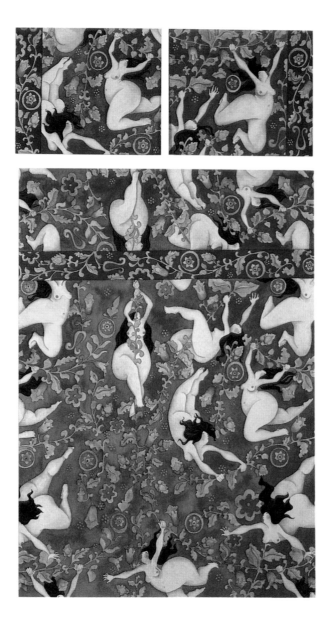

DESIGNER SHEETS

watercolor, courtesy of the artist, 1986

For years, Tennys Owens, owner of Artique Gallery in Anchorage and publisher of my prints, and I used to joke that maybe when I found "my niche" I would be designing bedsheets. So one year for a show, I put my tongue in my cheek and did a painting of the sheets I would design if I were designing sheets.

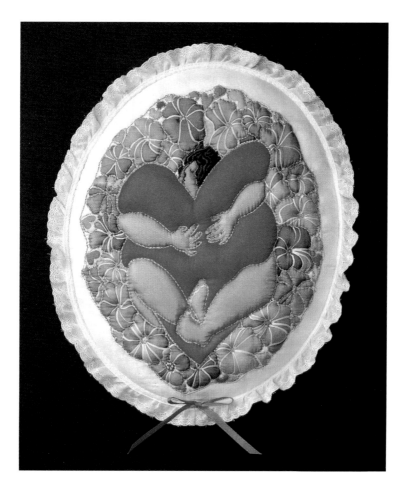

VALENTINE

dye on silk, courtesy of the artist, 1986

One year, an Alaskan newspaper asked a number of artists to do valentines for the February 14 issue. I love a chance to get "schmaltzy," so I chose to do a nude with both arms and legs wrapped tightly around a big red heart and surrounded by flowers.

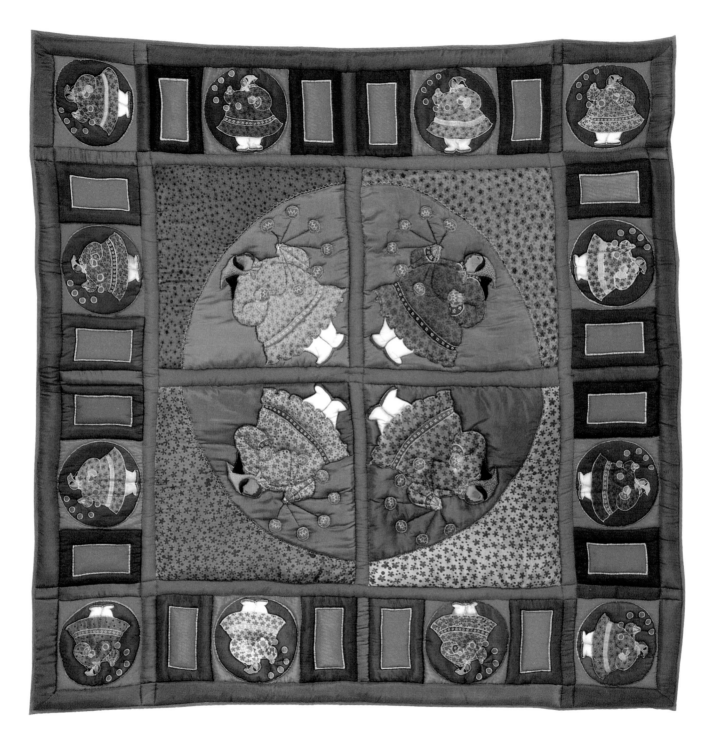

◀ ESKIMO YO-YO QUILT

dye on silk, courtesy of Debbie Daisy, 1986

Unlike a common American yo-yo, the arctic version is formed from a piece of braided seal gut with a fingerpiece at the center and a ball on each end. The object is to keep the two balls moving in opposite directions. I was first taught to yo-yo by my Alaska Native students, and it remains a favorite painting subject.

THEY COULD HAVE DANCED ALL NIGHT

dye on silk, courtesy of the artist, 1986

During the group dancing at the annual Indian and Eskimo Olympics in Fairbanks, I was inspired by the sight of everyone out on the floor doing their own thing and obviously having fun. I like this piece because it is not the bright colors that get your attention, but the stark whiteness of the gloved hands.

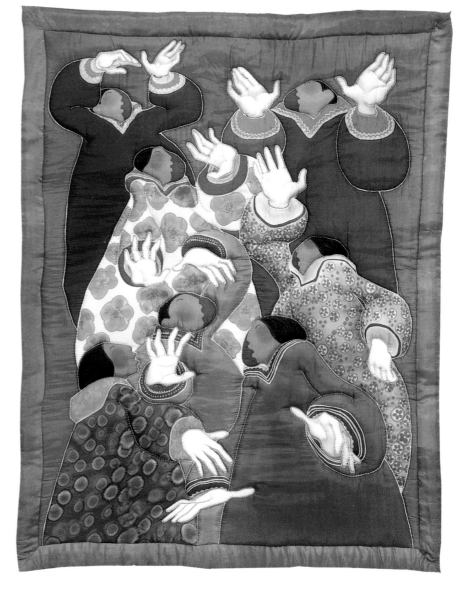

> "I've always been
> fascinated by the
> similarities and
> oneness of all
> people — as well as
> great differences."

RUSSIAN AMERICAN REUNION

(Alaska Airlines Triptych)
watercolor, 1991

The Russian influence on Alaska runs deep and extends along the entire coastline, providing a good many Alaskan surnames and a profound cultural flavor. After the United States purchased Alaska from Russia in 1867, changes in the political situation between the United States and Russia often resulted in borders being closed to travel.

I was in Honolulu, working on illustrations for a book about Japan, when the opportunity came about for me to do a triptych for Alaska Airlines, celebrating the resumption of their service to the Soviet Far East (Siberia). Reading everything I could about Russia in a Hawaiian library, I was fascinated by the elaborately carved windows and trim on wooden Siberian houses. I chose to use that to frame the Russian segments, while the totem pole signifies the Alaskan.

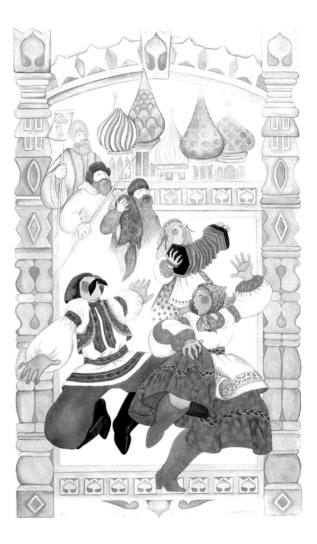

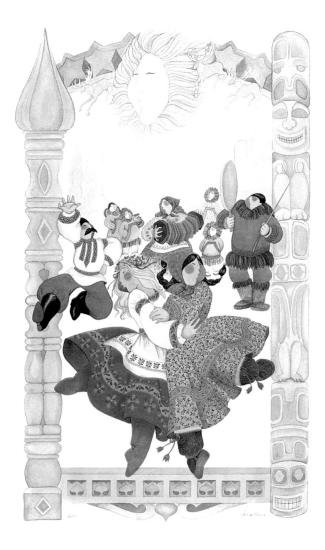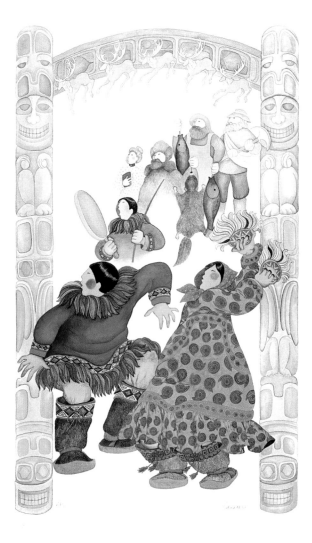

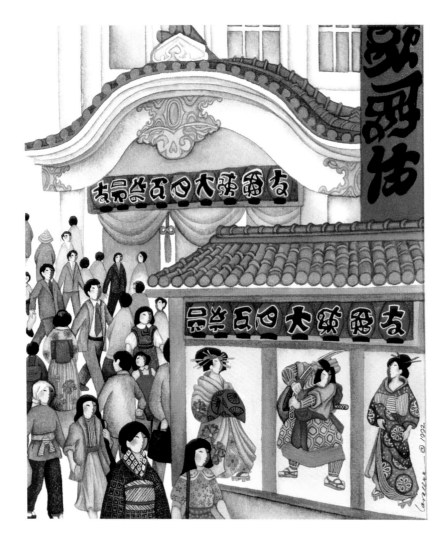

From the book,
This Place Is Crowded
1991, from the Imagine Living Here series, by Vicki Cobb, published by Walker & Co.

KABUKI THEATER, TOKYO
watercolor, courtesy of the artist, 1991

I love Japanese woodcuts, especially those known as ukiyo-e ("pictures of the floating world") the beautiful women, the samurai heroes, the courtesans and kabuki actors, as well as the calligraphy. Presenting the front of Tokyo's Kabuki theater gave me the chance to paint modern Japanese as well as the traditional warrior hero and beautiful ladies, and the banners with calligraphic characters.

SUMO WRESTLERS ▶
watercolor, courtesy of Billa Wollam, 1991

While researching the book on Japan, I became fascinated with the art form of sumo wrestling. Not only did this painting give me a chance to depict "men of substance," it also gave me a chance to explore some of the ritual and costumes peculiar to sumo.

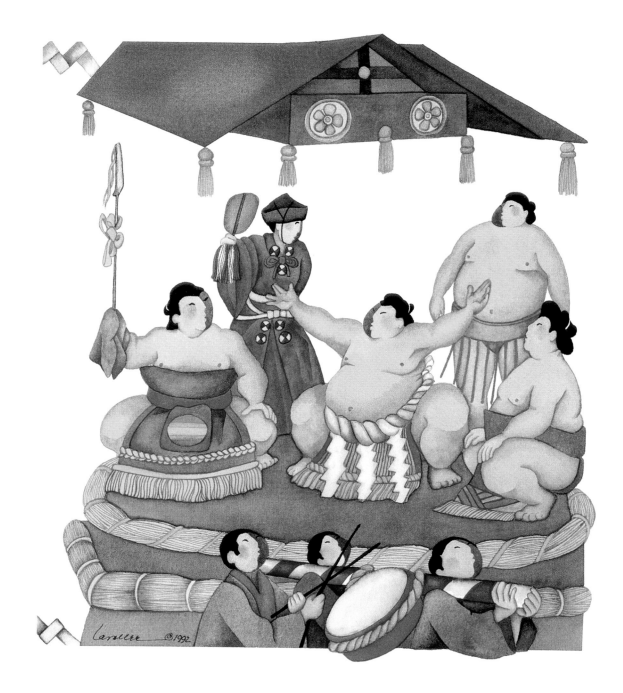

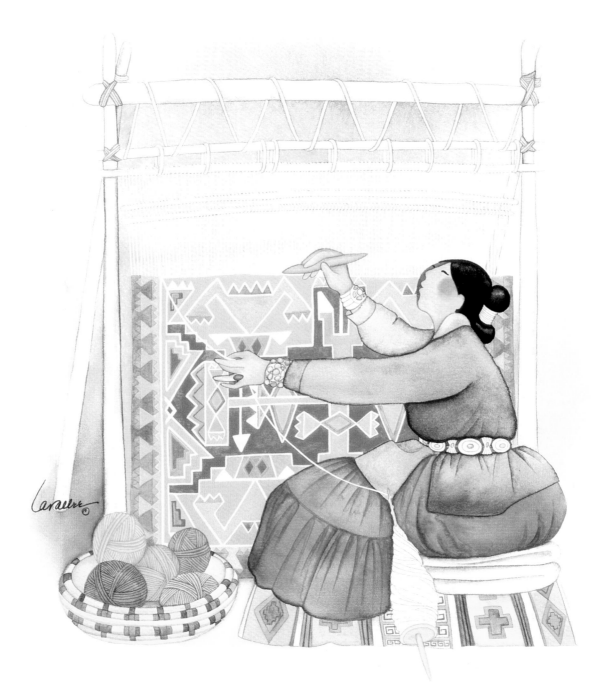

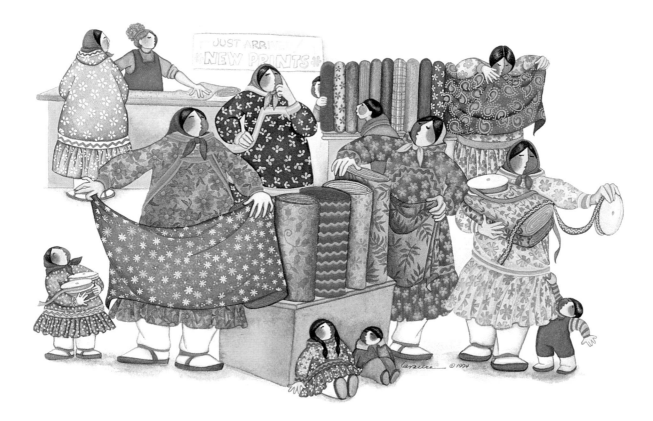

KUSPUKS BY THE YARD
watercolor, 1994

I was treated to this scene on one of my forays through an Anchorage fabric shop. Some Eskimo ladies were happily but seriously making their choices. They were selecting material for new kuspuks, traditional women's parkas that are brightly colored corduroy, cotton print, or velveteen on the outside and sometimes have fur linings on the inside.

◄ NAVAJO WEAVER
watercolor, 1994

Traditionally, Navajo women have raised the sheep and sheared them, then carded, spun, and dyed the wool, before finally weaving the rug on an upright loom.

"I have always loved drawing the human form and exaggerated it even in college."

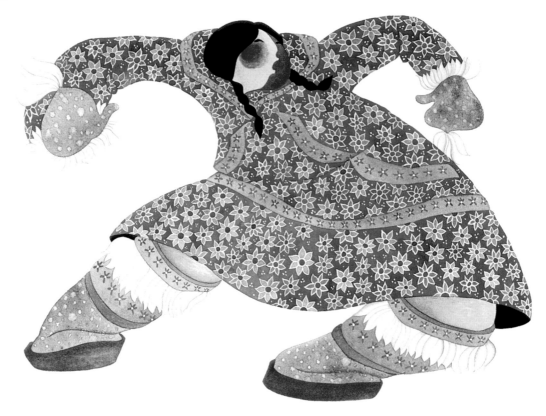

CLASSIC DANCER
watercolor, 1984

A poster for a Fairbanks PBS station, KUAC-FM and -TV, this Eskimo dancer doing her classic Native dance ties in with the station's classic format.

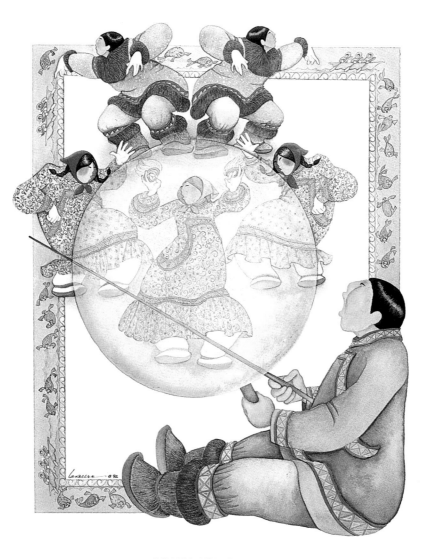

DRUM SONG
watercolor, 1992

*Used to keep the beat for singing and dancing,
an Eskimo drum is traditionally made of the
intestinal lining of large marine mammals, which
is tightly stretched over a wooden frame and hit
with a long, thin stick. A drum head made from
this material becomes transparent, allowing the
dancers to be seen behind it.*

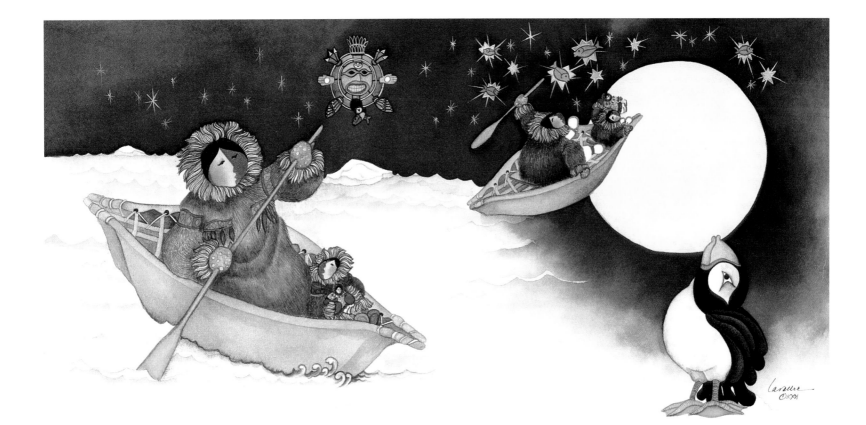

COVER FROM
MAMA, DO YOU LOVE ME?
watercolor, courtesy of Mark Lavallee, 1991

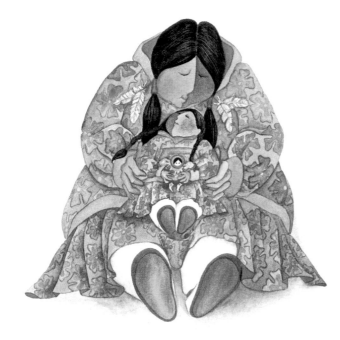

MAMA, DO YOU LOVE ME?
watercolor, courtesy of Marilyn Williams, 1991

From the book,
Mama, Do You Love Me?
by Barbara Joosse, published 1991 by
Chronicle Books.

This book was an illustrator's dream — a universal
concept couched in the trappings of a culture and
people that continue to fascinate me after over
twenty years of living in Alaska. I was both the
mother and the little girl. Only after the book had
been published did I learn that the author, Barbara
Joosse, had written the book about a mother and a
little boy.

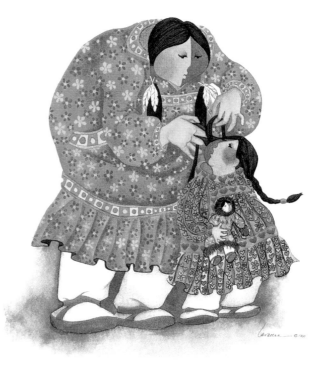

MEMORABLE MOMENTS
watercolor, 1991

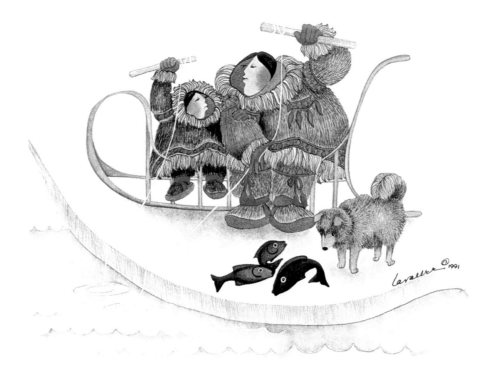

TOM COD FISHING
watercolor, 1991

*Tom cod is a staple food fish in the Arctic,
commonly caught in the winter through holes
chopped in the ice. Originally created for the cover
of the book,* Mama, Do You Love Me?, *this
painting was not used for that purpose, though it
did appear on the cover of a children's magazine.*

From the book,
This Place Is Cold
1989, from the Imagine Living Here series, by
Vicki Cobb, published by Walker & Co.

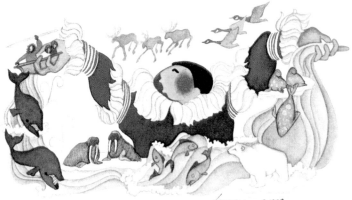

ARCTIC TALES
watercolor, 1989

*This illustration depicts the close connection
between the land, sea, animals, and people as
told by the Native storyteller.*

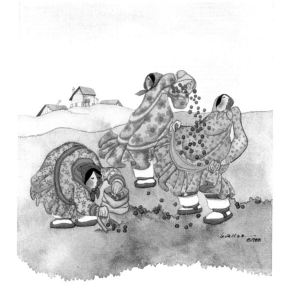

PICKING BERRIES
watercolor, 1989

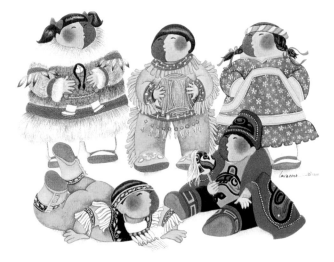

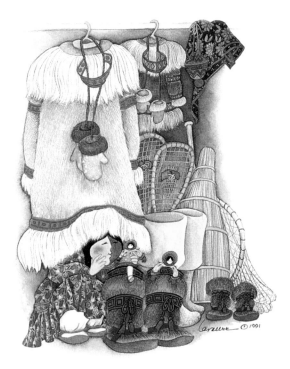

CHILDREN OF THE NORTH
watercolor, 1993

Yupik, Aleut, Inupiaq, Tlingit, and Athabaskan children in costume are just a few of Alaska's colorful kids. Some of the most beautiful costumes can be seen at the Indian and Eskimo Olympics, held every summer in Fairbanks, where the Mothers and Babies Contest is one of the most popular events.

CLOSET CAPER
watercolor, 1991

This painting proves that I have at least a concept of a tidy closet, in spite of the fact that in reality clean closets usually elude me.

VILLAGE TRADITIONS
watercolor, 1993

"Starring" is a unique combination of Eskimo tradition and Russian Orthodox religious ceremony, and takes place in January during the Russian New Year celebration. The villagers follow children carrying huge decorated stars from house to house, gathering treats and eats at each house along the way.

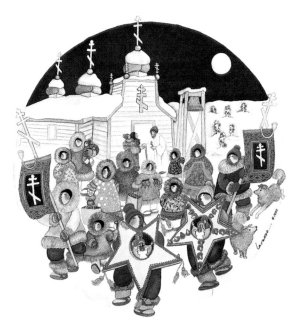

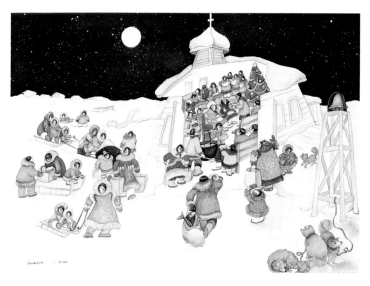

ALASKA VILLAGE CHRISTMAS
watercolor, 1993

I am most fortunate to have a friend who can paint wonderful word pictures. He spent several years in an Alaskan village and described this scene for me in great detail, for I have never witnessed a village Christmas. I could not decide whether to depict the exterior or interior scene, so I opted to show both.

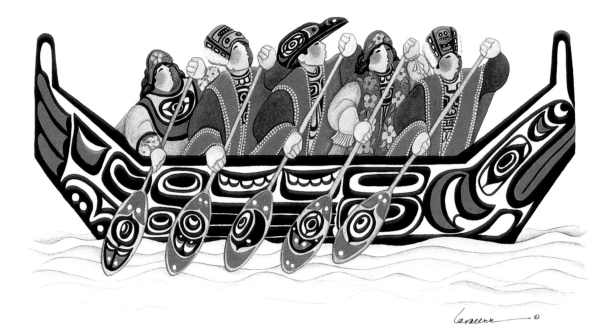

TLINGIT CANOE

watercolor, 1992

Button blankets, colorful beadwork, and totemic designs combine to make this painting of Southeast Alaska.

SITKA FOURTH OF JULY ▶

watercolor, courtesy of the artist, 1981

Sitka was the first place I had ever lived where a parade was never called because of rain. I marched in a lot of rainy parades, usually pulling a wagon full of kids.

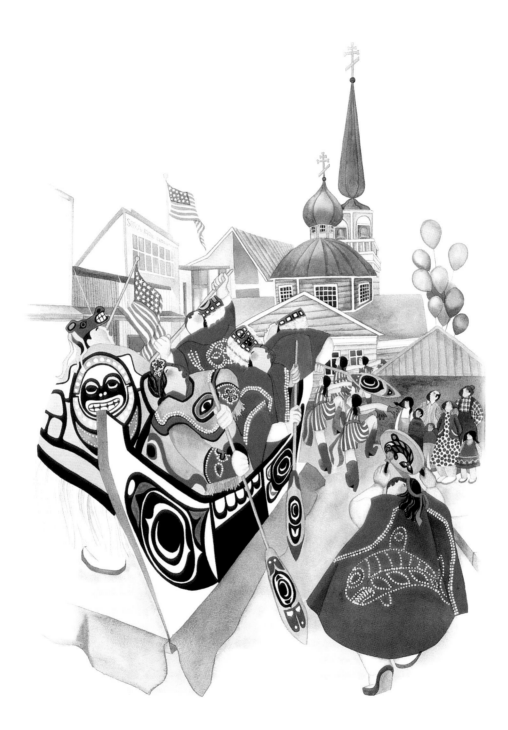

MORE CELEBRATIONS

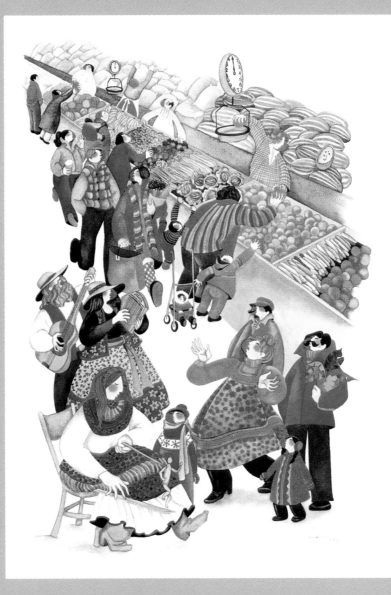

Special Places and Events

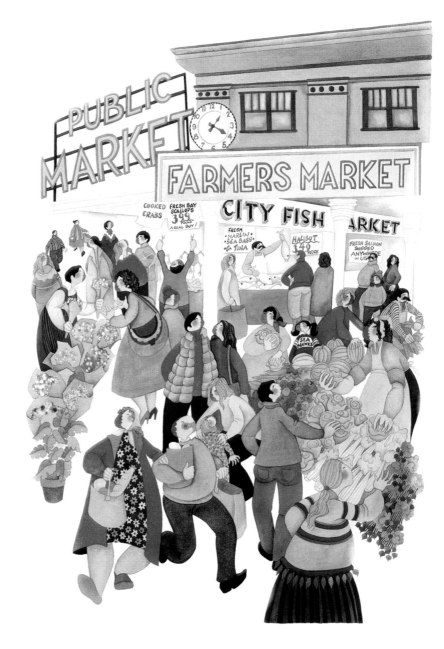

◀ **PIKE STREET MARKET**

watercolor, 1982

In this first of several paintings I did of Seattle's Pike Street Market, I concentrated mostly on the people I saw more than the wares they were selling.

SEATTLE PUBLIC MARKET

watercolor, courtesy of Gordon Godfred, 1985

A favorite place in Seattle, Pike Street Market provides countless subjects for a painter. I could find no reason to settle for just one subject, so, like the market itself, I crowded as much into my painting as space would allow.

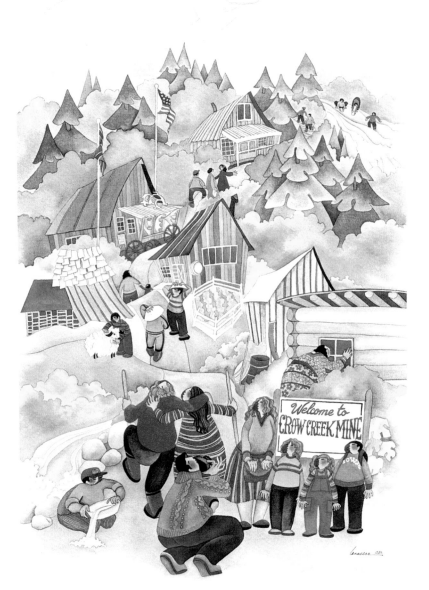

CROW CREEK MINE

watercolor, courtesy of Cam and Michelle Toohey, 1982

This is one of the first paintings I did after moving to Girdwood, Alaska, from Sitka. The boys and I visited the mine one weekend in September 1982, and to our delighted surprise, found ourselves the only humans around. I made up the people I painted in, so I was tickled to learn that Cynthia, owner of the mine, had picked out herself from among the people I'd imagined.

CROW CREEK MINE II ▶

watercolor, courtesy of Cynthia Toohey, 1985

The mine became part of our lives in Girdwood, as did the people who lived there. This 1985 painting shows many of the same structures, but is colored by the warmth of the people and memories of a special place.

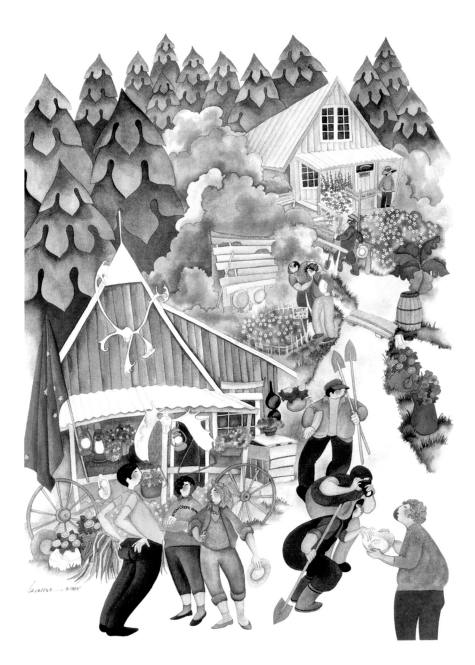

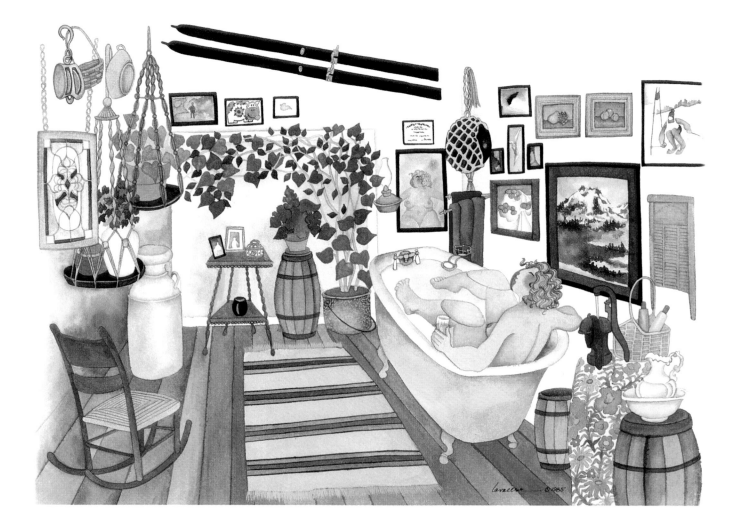

◀ CYNTHIA'S BATH

watercolor, courtesy of Cynthia Toohey, 1985

Probably the most special place for me at the Crow Creek Mine was Cynthia Toohey's bath-room. A flamboyant collection of memorabilia ranged from old skis to kids' drawings to a pipeline hard hat and stained glass windows. The mine is without electricity and running water, so water comes from a creek running behind the cabin. Hot water is obtained by filling the tub, lighting gas jets underneath, and heating the whole works.

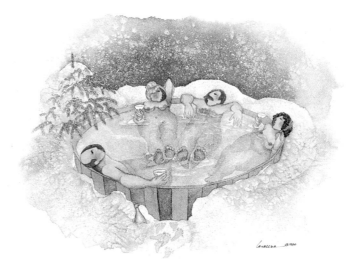

MOONLIGHT MARINADE

watercolor, 1990

Alaskan winters are perfect for hot-tubbing. One night in the middle of a good soak, a group of us decided that only when the temperatures got below minus 30 degrees F was it too cold. Nights with gently falling snow, or cold and crisp with squillions of stars, can be topped only by a spectacular display of northern lights.

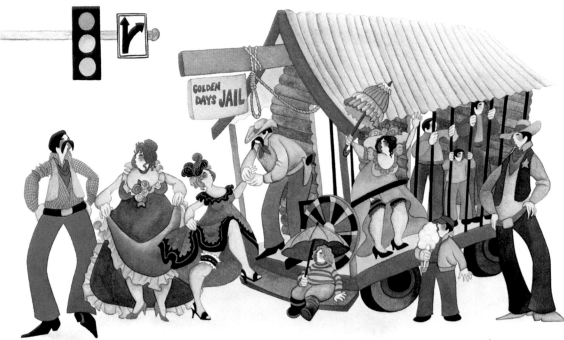

GOLDEN DAYS PARADE

watercolor, 1986

Golden Days is an annual Fairbanks bash to celebrate the discovery of gold. Fairbanksans wear period costumes during this celebration, and anyone found without a costume is fined or thrown into a mobile jail. I painted this poster for the 1986 Golden Days Celebration, tying it to the present with the traffic light.

GRAND MARSHALL OF THE PARADE ▶

watercolor, courtesy of the artist, 1986

Besides painting the 1986 Golden Days Poster, I was also honored to be the Grand Marshall of the parade. Truly a fantasy "once in a lifetime" experience, I rode through the streets of downtown Fairbanks in an elegant white carriage pulled by a beautifully liveried horse driven by a equally well-liveried driver. I painted this for myself to commemorate that day.

OLD MILWAUKEE

watercolor, courtesy of Dorothy Koehler, 1994

A 1994 Mother's Day gift for my mom, I did this from a favorite old photograph of my grandfather, who was once a milkman in Milwaukee. I added the child to represent my mother, also from an old photo in which she was wearing a beautiful white "birthday cake" of a dress.

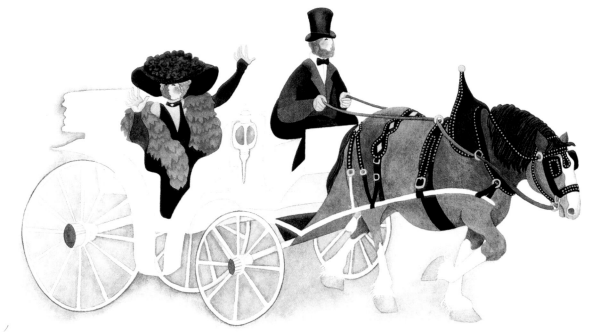

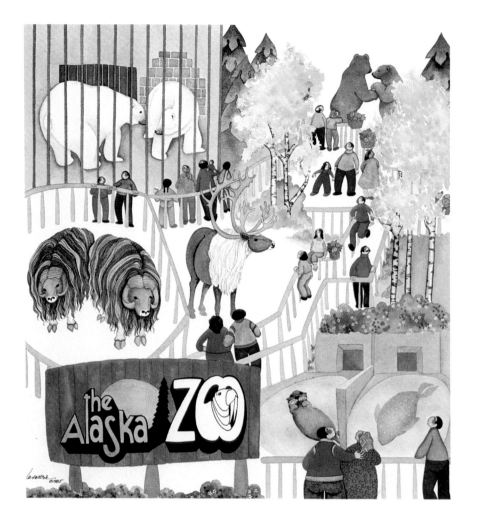

THE ALASKA ZOO
watercolor, 1985

Zoos are a favorite subject of mine because they allow opportunities to paint both the animals and the people enjoying them.

HONOLULU ZOO ▶
watercolor, courtesy of Debbie Daisy, 1981

I once had a month in Honolulu with nothing to do but paint. My boys were with their father, so I spent my days on the beaches or at the zoo and painted at night.

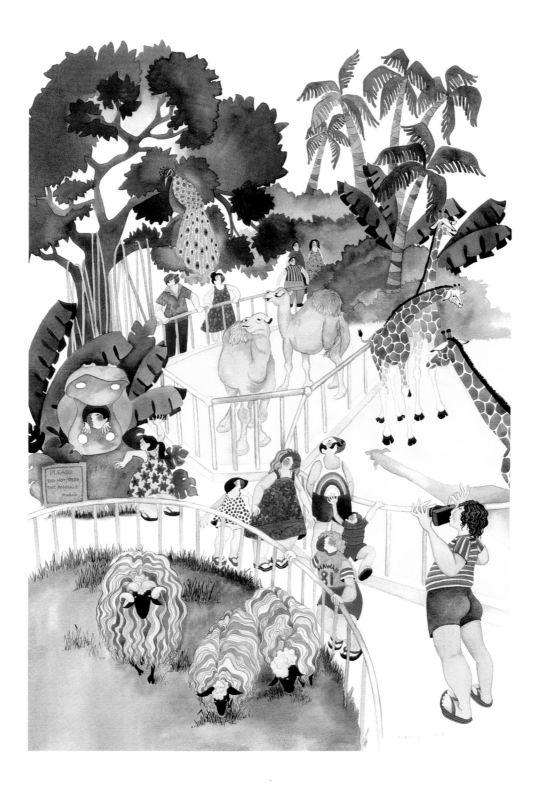

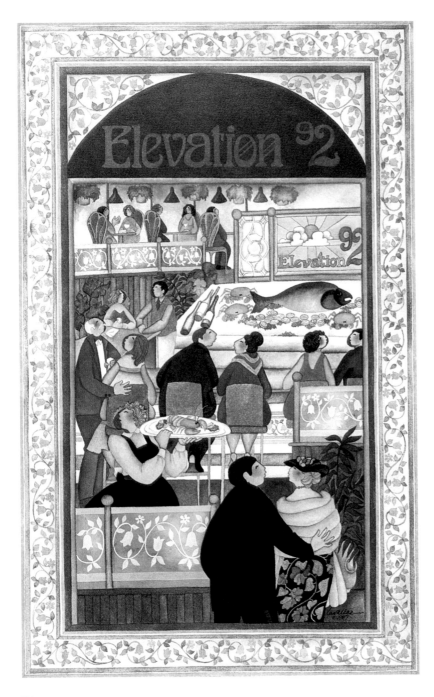

ELEVATION 92
watercolor, 1987

Used as a fund-raiser for the Anchorage Opera, this has always been one of my favorite paintings. A well-known Anchorage restaurant, Elevation 92, had just redecorated so I used the pattern of their new tile for the border. Frosted glass, green plants, and brass trimmings gave lots of opportunities for contrasting textures.

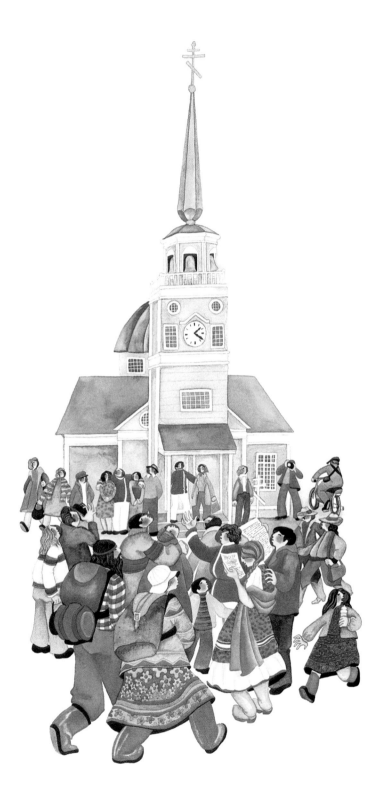

ST. MICHAEL'S — SITKA
watercolor, 1982

The Russian Orthodox church in Sitka, Alaska, occupies the center of the downtown main street. When cruise ships are in port in the summer, street traffic comes nearly to a halt because of all the tourists swarming the street to get photographs.

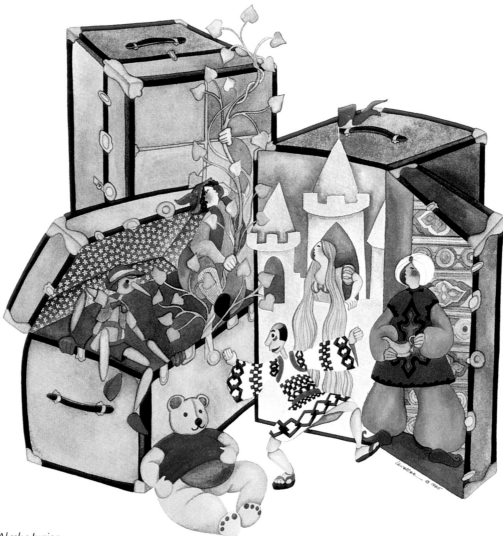

ALASKA JUNIOR THEATER

watercolor, 1985

*This piece was commissioned by the Alaska Junior
Theater for a fund-raiser poster. I did several
paintings before finally coming up with this one
depicting characters from children's stories coming
out of a theater trunk.*

Kids

From the book,
The Snow Child

by Freya Littledale, published 1989 by Scholastic.

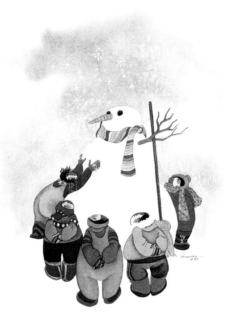

SNOWMAN

watercolor, 1988

To this day, a good juicy snowfall inspires me to want to make a snowman.

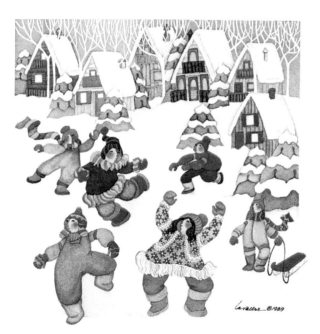

WINTER BREAK

watercolor, 1988

PUDDLE JUMPERS
watercolor, 1982

As the mother of two boys in Sitka, I cleaned up after a lot of puddles that weren't jumped successfully.

SCHOOL'S COOL
watercolor, 1993, courtesy of Ptarmigan School

Originally painted as a memorial to a former teacher, the print was used as a PTA fund-raiser in the Anchorage schools.

Cats

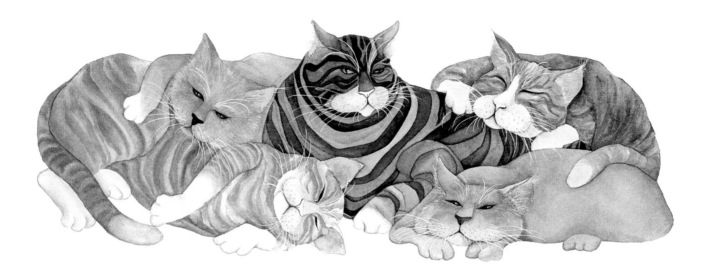

LAZY GREY CATS

watercolor, 1986

*My first cat painting. I was so unsure how it would
be received that I dropped it off at the gallery
without waiting for it to be seen.*

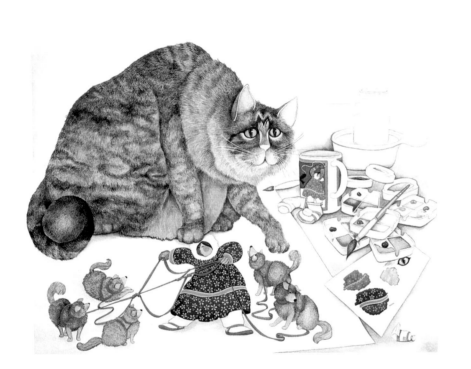

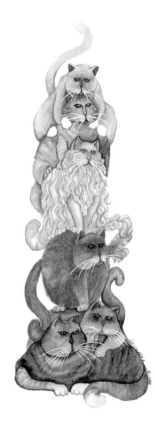

THE ARTIST'S CAT
watercolor, 1993

*Any person who belongs to a cat knows that
cats will always sit right in the middle of whatever
you are doing. My cat, Nerm, loves to sit under a
nice warm light where he knows there are hands
for petting.*

POLE CATS
watercolor, 1988

A stack of cats.

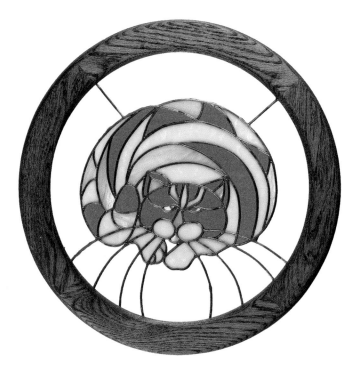

ROUND RED CAT,
CAT IN THE WINDOW

stained glass, 1987

I collaborated on these two windows with Girdwood stained glass artist Jim Kaiser. I had tried my hand at cutting glass and decided to enlist his incredible talent after cutting more fingers than glass on my own.

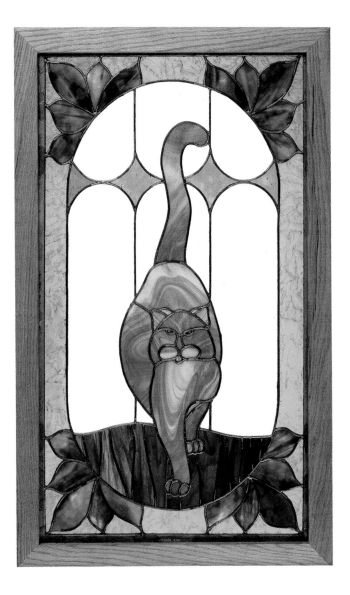

Soft Sculpture

"Each medium has special properties that make it fun, but each requires a big time commitment, as well as shoveling out the studio to make space. In the long run, though, everything I learn adds to my understanding of the creative process in general and my own art in particular."

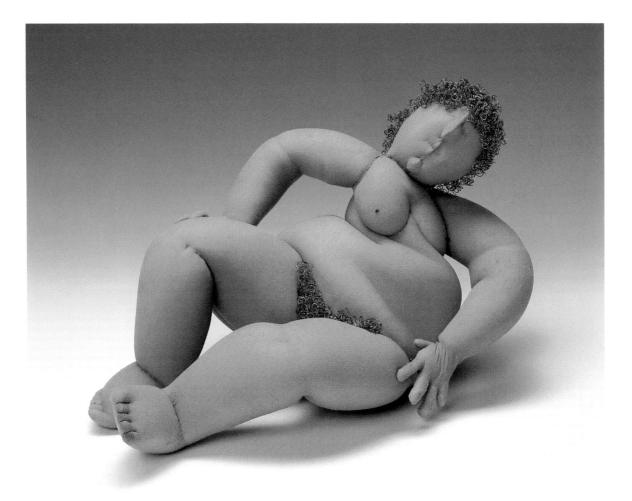

BARBIE AND KEN

courtesy of Jon and Charlotte Van Zyle, 1992

Made for a gallery doll show one Christmas, I carved the hands and feet out of a craft clay that hardens in an oven. Then I filled the bodies with sand so they would "settle" and hold the dolls upright when sitting. I made my Barbie and Ken middle-aged, with a bit less hair and more girth than they had thirty years ago. The clothing and accoutrements are the creations of Susan Ellis, a fellow artist, gallery manager, and friend.

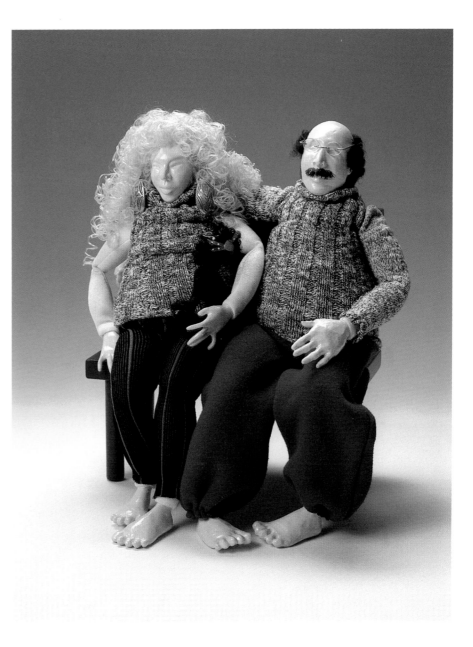

◀ RECLINING NUDE

courtesy of Marilyn Williams, 1984

Copper wire, tediously secured and curled around a knitting needle strand by strand, forms the hair and pubic hair for this bathroom sculpture.

Alaska

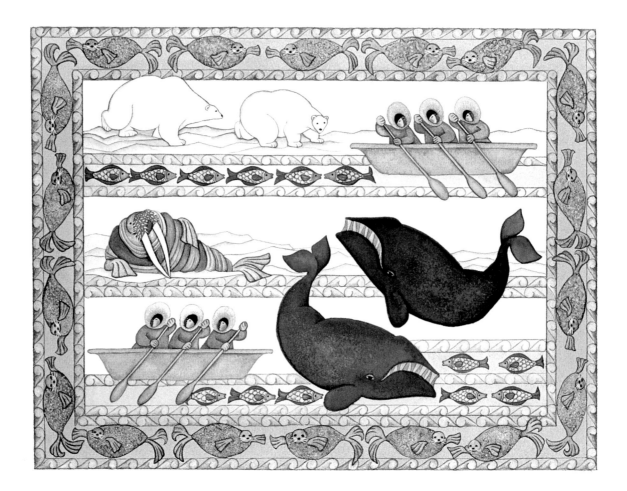

UNDERWATER ALASKA

watercolor, 1993

The sea is an important part of a coastal state such as Alaska, and the life underwater is as rich and colorful as it is on land.

◀ ARCTIC CYCLES

watercolor, 1992

It was inevitable that the techniques I've used in my illustrating and other designing would be incorporated into my painting. The use of borders and repeated elements make this painting more of a graphic design.

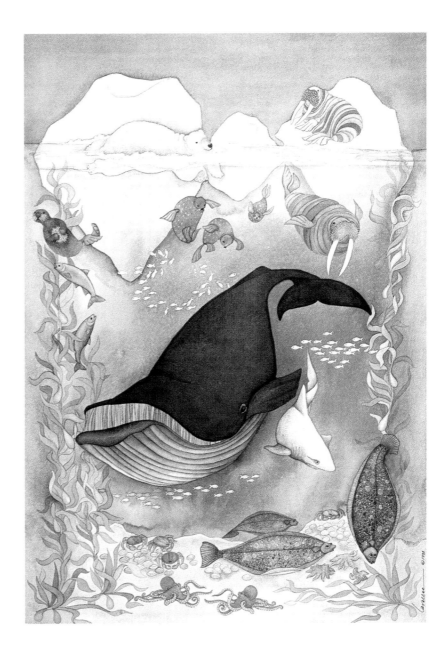

65

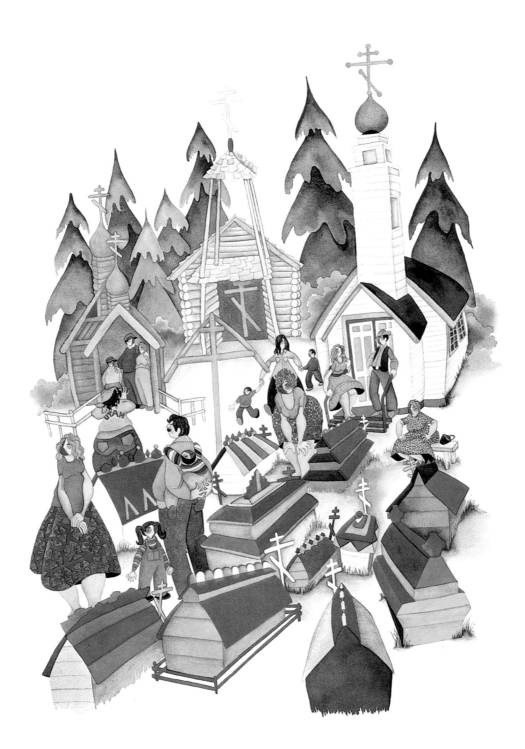

NEW ARCHANGEL DANCERS

watercolor, 1989

Formed by a group of local women in 1969, Sitka's New Archangel Dancers perform traditional Russian folk dances. For this poster celebrating their twentieth anniversary, I chose some of my favorite dancers and costumes.

◀ **EKLUTNA**

watercolor, 1983

Eklutna is an Athabaskan village near Anchorage. The Russian Orthodox church and cemetery with its colorful "spirit houses" are landmarks often visited by tourists.

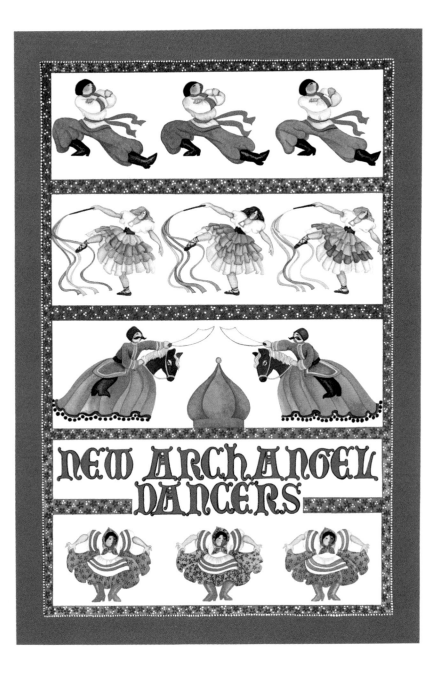

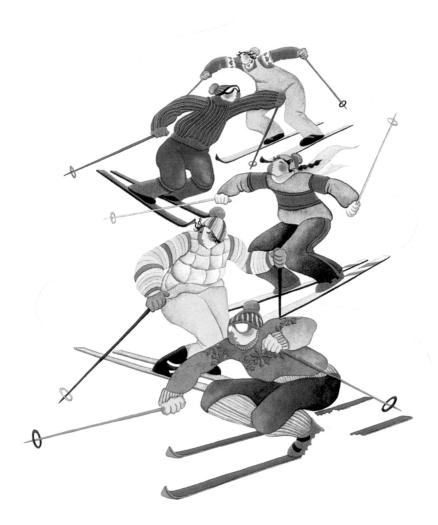

◄ SKIERS

watercolor, 1983

Skiers love virgin powder; I guess the idea of being somewhere before anyone else intrigues all of us, and if you've been somewhere first, you leave your mark. Grapevine tracks are skiers' way of showing that they have been there. Brightly colored ski clothing is self-decoration at its best, and I wanted to play it off the transient decoration made on the snow.

GLACIER CREEK ACADEMY

watercolor, 1986

Used as a fund-raiser for Glacier Creek Academy in Girdwood, some of these posters were signed by all the kids who attended the academy that year, including future Olympic Gold Medalist Tommy Moe, who won the downhill in 1994.

BARBARA'S STORY

For almost five decades, Barbara Lavallee's favorite subjects have been women. "I'm a woman and I do women. And I do not like wimpy women," she explains — seriously, but with an impish smile. "I do some men and kids in my paintings, but seldom do a painting of just men. Women are so much more colorful."

Barbara does not consider herself a feminist but feels fortunate to have been around during the feminist movement.

"I have met many strong, surviving women who have beaten the odds, so there's no doubt in my mind that women are equal. Sometimes better! I'm very happy being a woman. It's been an exciting time to be a woman."

Barbara is amazed at the strength of women, at their ability to keep at something until it's accomplished. "Women are the glue of society. I grew up surrounded by women who can take care of themselves. They keep things together, make the celebrations happen, care for the emotional and physical needs of the family. They perform the routine chores that keep a home and family running smoothly."

Many of Barbara's paintings depict these mundane chores: picking berries, braiding a child's hair, sewing clothing, fishing, preparing food, knitting, playing with children, helping men prepare for a hunt.

Her women are happy, in love with life, dancing, singing, laughing. Usually they are gracefully rotund. One reason she exaggerates the women she paints is because she wants them to be "... monumental ... women of substance ... well-rounded, with creases and folds and rolls to create shadows. I do not consider them fat. But they are not mere pieces of fluff in danger of blowing away in the next high wind, either."

No sad tales are told by Barbara's art. She paints life as she sees it — joyful, festive, colorful, fun. People usually smile when they look at a Lavallee painting, or even chuckle quietly, perhaps reminded of gentle times in their own lives. And that's what Barbara wants, for her art expresses her own philosophy of living.

Long-time friend and fellow artist Jon Van Zyle believes that most serious artists tend to expose themselves through their art. "There's a lot of Barbara in her art — always whimsical, comical, happy. When you look at her paintings you can see yourself in them, whether you want to or not. Barbara is a very funny person."

Barbara often emphasizes her words with a sideways glance, a broad and happy

The Koehler family in 1948, with sisters Dorothy, Mary, and Barbara standing, and Ruth in her father's arms.

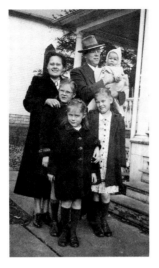

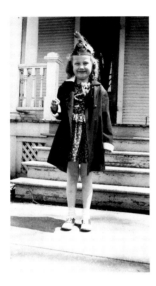

Barbara, already a budding artist at age 6, at home in Iowa.

enchanted forest. Barbara would illustrate the stories on a chalkboard. As Barbara's favorite subject, Sheena was always glamorously attired in exotic, colorful clothing.

"We spent hours dreaming of being glamorous women, telling stories about them, playing dress-up and pretending. As a preacher's kids we had a marvelous advantage: rummage sales for clothes and high-heeled shoes," explains Barbara, reminiscing. "But the most fun for me was drawing the figures on the board and dressing them."

On the first night of the family vacation in 1957, however, their life changed. Barbara's father died; her grandfather had a heart attack when he heard the news. Dorothy Koehler faced her husband's funeral, her father's hospitalization, the need to go back to work after sixteen years of homemaking, and an immediate move out of the parsonage.

Soon she was appointed Housemother/Dean of Women at a local college. Home for Dorothy and her daughters, by

smile, a fluttering of dark eyelashes, and subtly coquettish body language. Now a slender, energetic woman with a spirited giggle and a modest manner, Barbara grew up in a close-knit family in Wheatland, Iowa. Her father, minister Clarence Koehler, and mother, art teacher Dorothy Koehler, were a "real team" and deeply loved each other. Their pride in being college graduates influenced the Koehler sisters, who never doubted that they would also attend college. Their parents encouraged them to succeed.

As children, the four girls — Dorothy, Barbara, Mary, and Ruth — often took turns telling stories about "Sheena of the Jungle," a beautiful woman who led a carefree life, swinging on vines through an

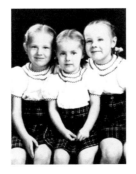

Barbara, Mary, and Dorothy proudly wear new outfits made by Grandmother Keeler, in Iowa, 1946.

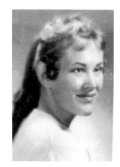

Barbara's high school graduation picture in 1960.

then young women, became the housemother's tiny apartment in the dormitory. After a few years, she returned to elementary school teaching when one of her girls told her there was no place to have a "good cry" living in the dorm.

One of Dorothy's proudest days was when she bought a house. Her childhood had been spent in rented "flats" and her married life in parsonages. The house was a milestone and an oasis for her daughters.

Barbara was strongly impressed with her mother's ability to create a warm, loving home for her daughters and get on with her life after her husband's early death.

"Mostly because of Mother, I never questioned my own ability to make a life for me and my kids after my divorce. Often Mother was my sounding board, always encouraging and supporting. I know that she is proud of what I do, though once she confessed that she herself could not stand the uncertainty of the variable income that an artist's life entails."

Since the days of Sheena of the Jungle, art has been a driving force in Barbara's life. Uncertain income is always a factor for an artist, she believes.

"In college," she says, "the prevailing attitude was that you got a real job to pay the bills and created art in your spare time. Only when you separated art from the

marketplace could it remain pure. I majored in art because I thought it was cool ... not because I thought I'd ever make a living at it.

"I was far from a serious student — my mother was convinced I was majoring in bridge and partying, and I'm sure I would have been among the last chosen by my professors as Most Likely to Succeed in the Art World."

Barbara's strongest subject was life drawing. "I have always loved drawing the human form and exaggerated it even then. The only thing guaranteed to get more groans from a life drawing class than a male model was a skinny female. Undulating flesh is infinitely more fun to draw!"

Graduating in 1964 from Illinois Wesleyan University with a Bachelor of Fine Arts in Art Education, Barbara applied to teach overseas with the U.S. Department of Defense. "I didn't have the experience for a teaching job, but I did have recreation experience, which got me a job in an Army Service Club in Lenggries, Germany. There I met my future husband, Tom Lavallee, who was a sergeant in the Green Berets."

They married in 1965 and lived in Maine while Tom finished school. Working in a series of social service jobs — in a hospital for the mentally handicapped, an adoption agency, and a job corps center for women —

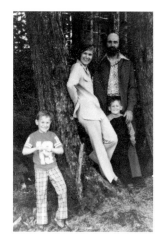

The Lavallee family in Sitka, 1975: Chip, Barbara, Mark, and Tom.

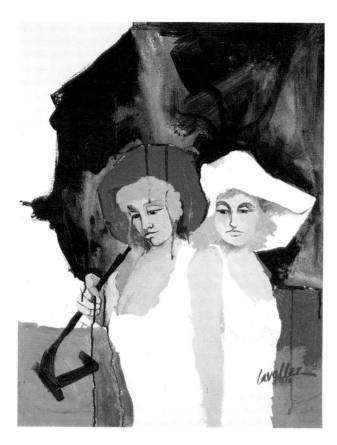

SITKA RAIN

acrylic, courtesy of the artist, 1978

This is not only my first acrylic but also my last. The darned paint dries out and is rendered useless (unlike watercolor, which can be reconstituted anytime). It is also the only painting I have ever done like it, and was a burr under my saddle until I finished it. Then it was as if I had nothing more to say. I guess after you've said it rains in Sitka, you've covered everything.

gave Barbara a picture of life she had never seen before. "I've always been fascinated by the similarities and oneness of all people — as well as great differences. Even then I was noticing the similarities as well as the differences in the people I met."

The lure of adventure beckoned again when Tom graduated in 1968 and was offered a job teaching on the Navajo Reservation in Arizona.

Tom remembers, "I looked forward to my new teaching job, but Barbara's world consisted of a cafe, trading post, and boarding school in the middle of the desert. Shopping for anything but necessi-

ties required a 320-mile round trip to Farmington, New Mexico.

"Until she began teaching art in 1969, we had floors clean enough to eat from and Barbara still had free time. So she volunteered to work at the hospital where our son, Chip, was born in 1969. When we transferred to Alaska in 1970, Barbara had become so enchanted by the desert that she cried when we left."

Barbara's interest in an art career sharpened when she moved to Alaska. They drove to Prince Rupert, B.C., then discovered a fascinating new world traveling through Alaska's Inside Passage by ferry to Sitka. Teaching jobs and new adventures awaited them at Mt. Edgecumbe, a Native school on a nearby island.

"Alaska really grabbed me," she remembers, and the young state became a focal point for her life and her art. After her son Mark was born in 1972, Barbara started teaching an after-hours crafts program, converting attic storage space at

73

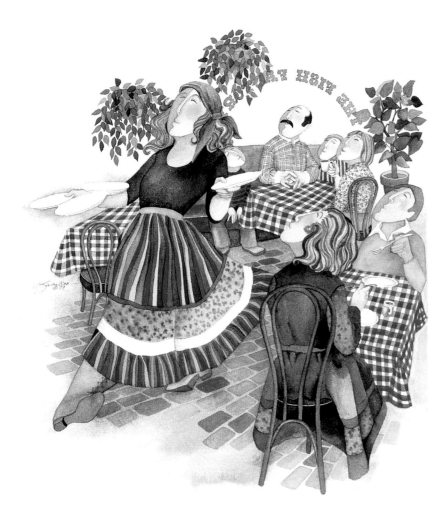

THE FISH FACTORY
watercolor, courtesy of Tom Lavallee, 1979

This is one of the first pieces I did in my emerging style, and a real vanity piece. It was a gift to my husband to celebrate the opening of our restaurant, and includes all the important stuff: our groovy hippie waitress, who could carry a load of plates all the way up her arm, and our family shown in the background.

the school into a teaching studio.

Through the class, she came to love the Native children and was intrigued by glimpses of village life she saw through their art — a lifestyle she found fascinating.

"The children were very interested and creative. My classroom was enormously active, and life was very exciting. My students deserve a lot of the credit for my career, because the happy, optimistic, carefree subjects I paint today come directly from those kids."

In 1975 Barbara made a major decision. The school asked her to teach full-time, and on the day she was to sign the contract Tom asked her what she wanted to do. That was the day she finally said it. "I want to paint full-time!"

So, instead of signing the contract, she resigned. "... And I have never regretted it," she states emphatically.

The couple had just built a new house. Tom had enjoyed the work so much that he quit teaching to become a building contractor. In a short time the Lavallees went from the security of two government incomes to the uncertainty of entrepreneurship.

Barbara did whatever jobs came along, "from painting names on boats and one memorable dump truck to making squillions of little Eskimo dough Christmas ornaments." Although the ornament business was profitable, Barbara wanted to concentrate on her painting style.

She painted long hours every day, became active in an arts organization, and worked in its gallery during the tourist

season. Then came a significant day. She sold her first painting — for $100 — to a couple on a cruise ship. She remembers well the painting of a walrus and the man who bought it: he was wearing a touristy fur hat on a summer day.

Tom, wanting new challenges, opened a restaurant, "The Fish Factory," which began an exciting, furiously busy time for them, fun at first. Then came the sameness, problems, seven-day weeks — and Tom's fortieth birthday. "He was ready to move on, with visions of sunsets on Hawaiian beaches," Barbara says matter-of-factly, "and I wasn't."

Barbara describes Tom as an adventurer, loving to begin new projects in new places. He wasn't looking for that special place to be home forever. But Barbara was. In 1980 Tom moved to Hawaii, and Barbara found herself with two young kids, a mortgage, and a struggling restaurant. "I preserved my sanity by unloading the restaurant, signing the papers on my way to the airport for a show in Anchorage," Barbara explains.

By this time she had shown in galleries in Anchorage and Southeast Alaska and had begun creating limited edition reproductions. Opportunities to show around the state grew. "But the art business is seasonal, the checks variable. I never knew how much I would get, so I had the conflicting emotions of expectancy and dread when the check showed up in the mail.

"If a check happened to be more than I

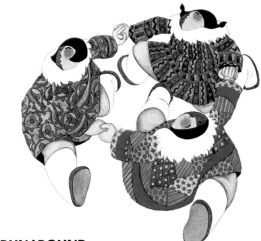

ESKIMO RUNAROUND
watercolor, 1980

One of my first paintings to be made into a limited edition print. I chose a universal children's game and dressed my characters in Native kuspuks.

needed, there were extras. If less, I kept a list of people who wanted commissions, and during lean months, I would paint as many as I needed to keep afloat."

Today Barbara is secure as an artist and book illustrator whose work is popular in many nations. Her captivating characters have been featured in hundreds of prints, magazine articles, commissioned works, and a dozen books. More than a million copies of Lavallee-illustrated books have been sold.

Her days are packed to the brim with family and work, the twin foundations of her existence. Divorced since 1981, Barbara raised her sons as a single mother. Now young adults, Mark and Chip run the

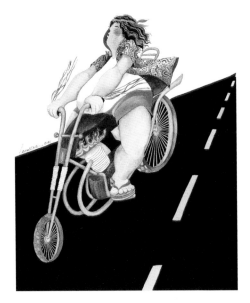

KONA BIKER
watercolor, courtesy of Chip Lavallee, 1981

I gave this painting to my son on his fourteenth birthday ... probably not his heart's desire for a birthday present, but one of his favorite paintings nonetheless. Whenever my sons and I were on vacation in Hawaii, we all loved to watch Hawaiians ride their "hogs."

family business, "Lavallee and Sons," a direct mail company that sells her artistic creations featured on greeting cards, T-shirts, coffee mugs, books, prints, and other items.

The company has grown out of one of Barbara's dreams — to work with her family. Envying families that worked closely together, she had long aspired to involve her sons in her work. Now Barbara, Chip, and Mark are learning a business from the bottom up, from concept to reality, with guidance from Tom.

Barbara loves being able to work at home, and has learned that she has the will power to accomplish the work she wants to do. She loves the lifestyle of a self-employed artist — setting her own schedule, choosing projects and subjects and travel opportunities.

"I have enormous self-discipline," Barbara says seriously, "though sometimes I fight a real battle between the social me and the solitude required to create."

The discipline, she believes, results from the need to produce enough work to make ends meet. "I know many talented people who never quite develop. I have very little patience with people who spend time talking about what they want to do instead of getting in there and just doing it."

Alaska has become her permanent home. She can't imagine living anywhere else. She loves the changing quality of Alaska's light, the visual overload, the magnificence of a constantly changing landscape.

Yet she doesn't paint landscapes. Barbara uses little background in her paintings — often none — making figures the primary interest. She prefers playing hot colors and patterns off against a stark white background.

Most of her subjects are women because, she says, "that is what I know, and they

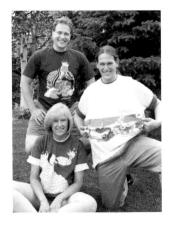

Barbara with sons Chip and Mark, wearing Lavallee-designed shirts (1994).

are better at costuming than men. I love to paint brightly colored clothing, and often I serve as my own model, using a full-length mirror in my studio. I'm not adverse to painting men, but most often when I do, they are Native dancers in full regalia."

Curiously, when Barbara does include men in a painting, they tend to be relatively slender, with exceptions. A favorite male image is an obese Japanese sumo wrestler she painted in Japan. She found these huge men to be fascinating subjects for her art.

Barbara also expresses affection for the men in her own life, though she now prefers living alone. "I have many good men friends," she says, smiling. "I can't imagine life without them. I am forever intrigued by the differences between men and women. It's fascinating to hear a male point of view."

With her sons grown, Barbara lives and works in Anchorage in a bright corner apartment/studio overlooking Cook Inlet with a glimpse of Mt. McKinley. Her studio resembles a playroom for a grown-up little girl. African and Eskimo masks, Japanese prints and lanterns vie for space with a Soviet flag bought from kids in Russia. Favorite antiques — her grandfather's carpenter saw, a gingerbread cutter, a wash board, a railway oil can, and a pedal kiddie car — share space with a fax, computer, and printer.

Large windows and ten-foot ceilings enclose the 600-square-foot work area, dominated by a drawing board, a large

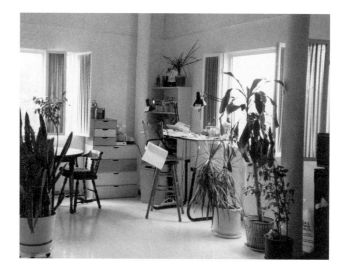

The working corner of Barbara's studio in Anchorage, with a view of Cook Inlet and Mt. McKinley out of the window by her work table.

work table, and a telephone with an off-switch for when she's working. Nearby are bookcases, an eight-foot cherrywood antique mirror, an exercise machine, a five-foot rubber plant, and an overstuffed settee.

Years ago she created a life-size, soft sculpture nude called "My Lady," designed to sit on a park bench in a friend's atrium. But Barbara kept it because she knew she'd never make another. "My Lady" now sits pertly, legs crossed, on a chair beside the kiddie car.

In this room, art is Barbara's obsession as well as job, and time often vanishes as she works sixteen hours at a stretch, at her drawing board by 5 a.m. Starting the day with coffee, she exercises while ordering her thoughts, "discarding baggage," visualizing pictures that she can move around, mentally watching them evolve, before putting them on paper.

At the beginning of any project, she does a detailed drawing. "I attempt to empty my mind and be totally involved

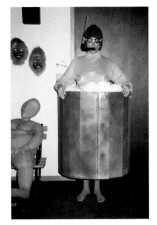

Barbara in her Halloween costume, "The Hot Tub," in 1986, with her soft sculpture "My Lady," bald because Barbara is wearing her bathing cap.

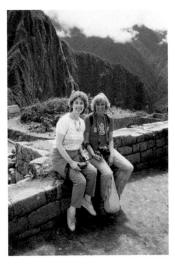

Barbara with author Vicki Cobb at Machu Picchu in Peru in 1988, researching for their book, This Place is High.

with the painting, visualize it. It's imperative for it to be perfect in my mind." Then she works through a drawing and subsequent tracing, planning how she wants the painting to look and how she will achieve the result. When satisfied, she traces it onto watercolor paper.

Each piece goes through these stages, from mental visualization to pencil sketch to the actual painting in color. Along the way, each piece constantly changes as color is added to different areas and new colors are laid next to others. Barbara likes to be deeply involved with each painting, so she prefers to work on only one at a time.

She scrupulously controls her work. There are no shortcuts. "The time saved by skipping elements in preparation generally

is lost several times over as you go back to get it right," she says.

As years flow by, her enthusiasm for painting grows. "Once," she says, "producing art was a choice. Then it became a passion. Now I have to do it." She has many "magical moments," which she describes as "the feeling that I'm in exactly the right place at the right time, doing exactly the right thing ... the feeling that all is right with the world."

To Barbara, art is "... a wordless experience in life and just being. Work has no deeper meaning than to bring joy, evoke happiness."

She awakens this happiness through a variety of media — needlecraft, handwork, dolls, silk painting. She has tried printmaking, etching, and wood-carving, as well as working in ceramics, serigraph, soapstone, ivory, silver, and stone lithograph. Though watercolor painting will always be number one, each year she tries a different medium, believing that the challenges keep her growing as an artist.

"Each has special properties that make it fun," she says, "but each requires a big time commitment, as well as shoveling out the studio to make space. In the long run, though, everything I learn adds to my understanding of the creative process in general and my own art in particular."

Travel is also essential to her art. "It revitalizes my emotion and energy and gives me ideas," Barbara says. People from many of the twenty-five countries she has visited

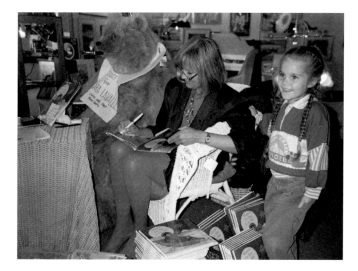

Barbara with a happy reader, signing copies of Mama, Do You Love Me? *in Seward, Alaska, 1992.*

appear in her illustrations in the Imagine Living Here book series, written by Vickie Cobb. Barbara is especially intrigued by places, like the former Soviet Union, that are changing and that are permitting travel after being closed for years.

In her travels, Barbara speaks often to adult and children's groups. When Barbara visits schools, she tells children that she has the best job in the whole world. "... And when I say it, I really mean it. But when I try to give it a job description, I have to wonder how many takers there would be for the classified ads."

FREELANCE ARTIST WANTED:

Requires self-motivated person who must be willing to work long hours alone at often tedious tasks. Applicant is responsible for inspiration and follow-through to completed masterpiece. Work will be constantly critiqued by everybody with eyes, and artist will be given immediate knowledge of successes or failures in the eyes of those critics. Pay is variable and uncertain, but offers unlimited promise.

No paid vacations, health insurance, or sick leave benefits. You are allowed all the days off you choose, but only you can do the work — you can't hire somebody else to do your job. Retirement benefits are up to you.

Benefits: Freedom to do work you love, to create a reality of your own and a space where you have control. Opportunity to reach others, to present them with your message, and to connect with other humans ... perhaps even make them feel good.

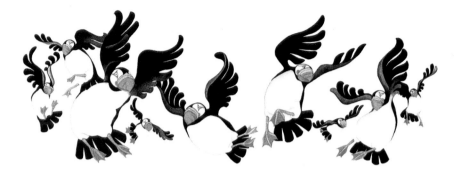

PUFFIN REVIEW
watercolor, 1984

Puffins are fun to watch because they are funny birds. Humans love them because of their entertainment value, not because they are graceful or fast, but because they will rocket in for a landing like an eight-year-old heading for the bathroom.

Image Index